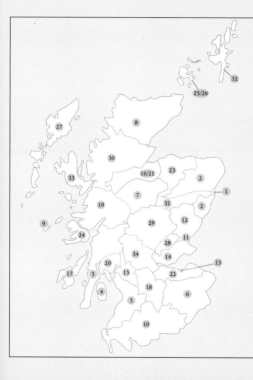

1. Aberdeen
2. Aberdeenshire
3. Argyll
4. The Isle of Arran
5. Arran & Ayrshire
6. The Borders
7. The Cairngorms
8. Caithness & Sutherland
9. Coll & Tiree
10. Dumfries & Galloway
11. Dundee
12. Dundee & Angus
13. Edinburgh
14. Fife, Kinross & Clackmannan
15. Glasgow
16. Inverness
17. Islay, Jura, Colonsay & Oronsay

23. Moray-Speyside
24. Mull & Iona
25. Orkney
26. Orkney in Wartime
27. The Outer Hebrides
28. The City of Perth
29. Highland Perthshire
30. Ross & Cromarty
31. Royal Deeside
32. Shetland
33. The Isle of Skye
34. Stirling & The Trossachs

The remaining six books, *Caledonia*, *Distinguished Distilleries*,
Sacred Scotland, *Scotland's Mountains*, *Scotland's Wildlife* and
The West Highland Way feature locations in various parts of the
country, so are not included in the map list above.

PICTURING SCOTLAND

THE ISLE OF ARRAN

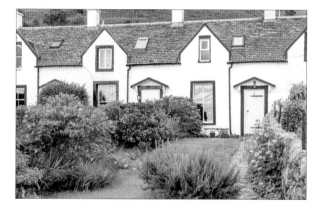

COLIN & EITHNE NUTT
Authors and photographers

lyricalscotland

2 An Arran mountain panorama from the viewpoint south of Brodick. From left to right the peaks are
 Beinn Nuis, Beinn Tarsuinn (shadowed), Beinn a'Chliabhain (lit), A Chir (shadowed), then right

THE ISLE OF ARRAN

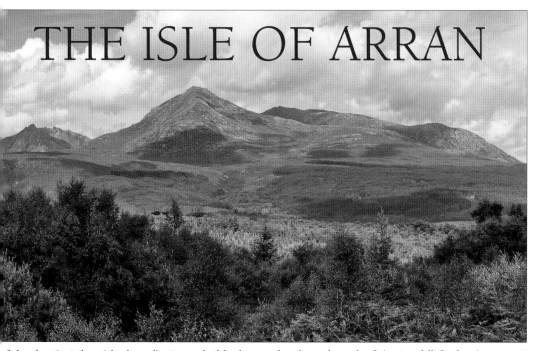

of the dip Cir Mhor (shadowed), Caisteal Abhail immediately to the right (lit), Goatfell (highest), Mullach Buidhe (shadowed) and Am Binnein (shadowed).

Welcome to the Isle of Arran!

The Isle of Arran sits cradled within the stretch of sea between Ayrshire to its east and the Mull of Kintrye to its west. It is often described as 'Scotland in miniature' because, just like the rest of Scotland, it has everything! It can be clearly seen from the Ayrshire and Argyll coasts, a tantalizing reminder of its existence, just begging to be explored – and, indeed, it is much visited. The ferry operator, Caledonian MacBrayne, takes more people to Arran annually than any other Scottish island that it serves.

The population of Arran was 4,629 at the last census in 2011. It has a circumference of 55 miles. The island is well-endowed with thriving, interesting and useful shops. The Arran Distillery is well worth a visit as are the Arran Brewery, Arran Aromatics and numerous art, craft and tea shops, many of which sell items produced on the island.

Over the years various re-organisations of the traditional counties have taken place and Arran, which was originally part of Bute, was transferred to Cunninghame. In 1996, regions and districts disappeared and were replaced by 32 unitary council areas. So Ayrshire was then split into North, East and South Ayrshire and Arran, which is west of the mainland, is administered by North Ayrshire Council.

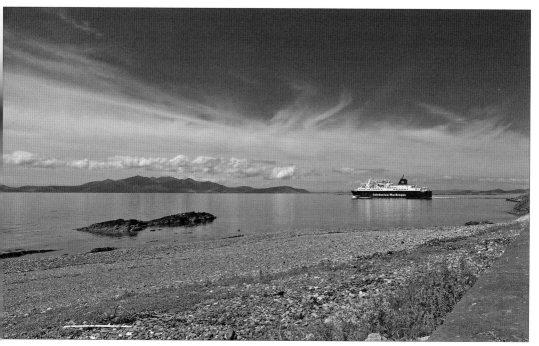

The journey begins! The ferry *Caledonian Isles* sails from Ardrossan towards Arran, stretched out on the horizon with a crown of low cloud above it. 5

In Neolithic and Bronze Age times Arran was a hive of activity. Many notable sites remain, offering tantalizing hints about life then, while at the same time keeping many secrets. The west coast has a wealth of stone circles, chambered cairns and standing stones. These go back as much as 4,500 years, begun in Neolithic times and gaining the stones that remain today during the Bronze Age. Machrie Moor has the greatest concentration of these monuments: a sacred landscape where a complex story of belief and ritual has unfolded over thousands of years. The one shown opposite gives an idea of the scale of the larger stones. Although this one appears to be solitary, it was once part of a circle, the other stones of which have been removed or lie buried in the peat that now covers the moor.

The climate can be extremely variable but it is warm enough for palm trees to flourish and, although not directly in contact with the Gulf Stream, its proximity to the Mull of Kintyre must provide some benefits. A ferry also sails from Lochranza to Mull of Kintyre for those who might enjoy a trip without having to go the long way round.

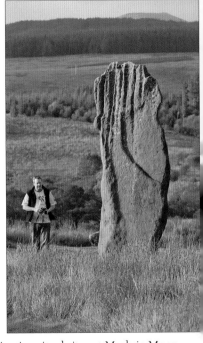

6 Standing stone: at Machrie Moor 3, one of a network of fascinating ritual sites at Machrie Moor – see pages 45-47.

Its character is extremely diverse. On the wild side there are craggy mountains, Goatfell being the highest while Cir Mhor is the most challenging. Arran's top 10 peaks are all above 610m/2000ft. The island is blessed with lovely glens, waterfalls and rivers and a fine collection of villages. The port and main resort is Brodick, nicely framed by the backdrop of Goatfell and the surrounding mountains which provide a constantly changing scene according to the time of year, the weather conditions and the time of day.

It is also extremely fertile in parts with most farming on the south and south-west of the island. It is famed for its amazing range of 'Arran' potatoes, for instance the famous *Arran Pilot* to name but one. Much more can be found out about these and the history of the island at the The Isle of Arran Heritage Museum which has an excellent and ever-growing collection of farm, family and island information, mostly given by families who have lived there for centuries. A few hours spent there would be well-spent indeed!

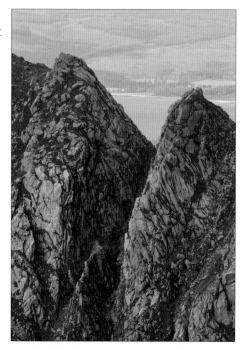

Up in Arran's mountains, the Witches' Step is a dramatic sight and tricky obstacle for walkers and climbers.

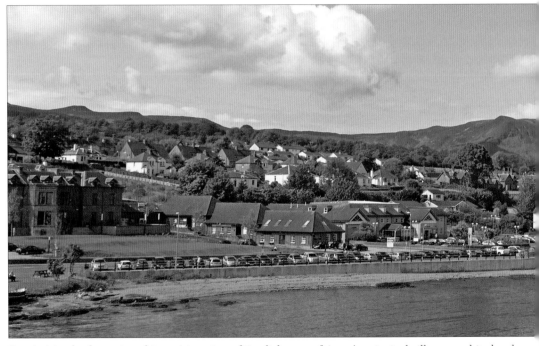

8 Arriving by ferry gives this enticing view of Brodick, one of Arran's principal villages, and its lovely
 setting – a great first impression, hard to beat. Part of Arran's lasting appeal is that it is full of variety

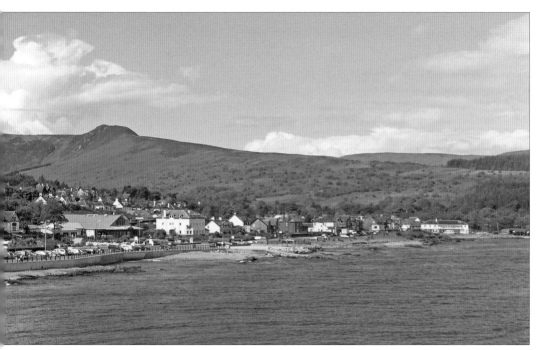

and large enough to explore time and again and each time to discover something new while it also remains intimate and friendly.

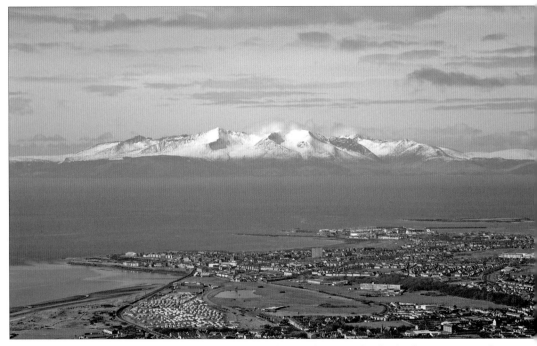

10 An aerial view of Arran, showing its proximity to the Ayrshire mainland. The ferry crossing takes under an hour. In this winter view, the Arran mountains are dressed to impress in their winter clothes

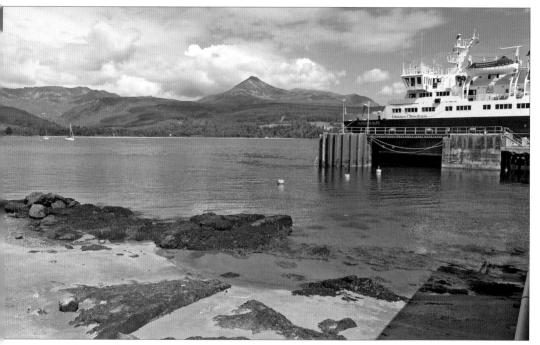

Disembarking from the ferry the sight of Goatfell, Arran's highest mountain at 874m/2866ft, draws the eye.

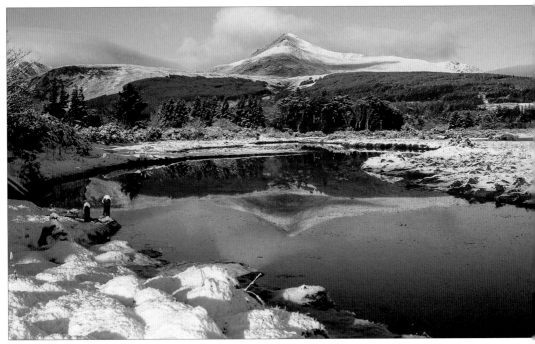

12 Fast-forward a few months and this view of Goatfell reflected in the waters of Fisherman's Walk near Brodick shows Arran at its scene-stealing winter best.

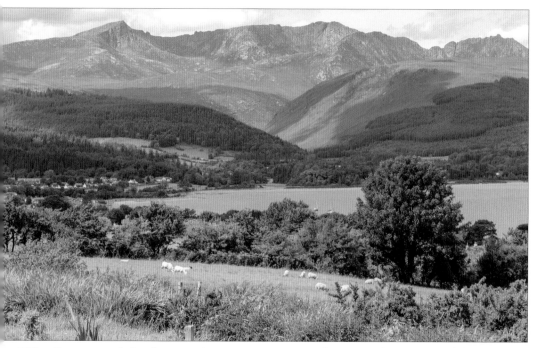

Hill walkers are spoilt for choice on Arran, as is apparent in this picture from near Brodick. Beinn **13** Nuis (792m/2597ft) stands on the left, from where a ridge leads to Beinn Tarsuinn (826m/2708ft).

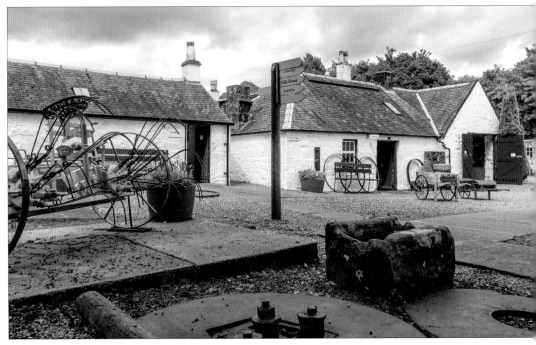

14 The Isle of Arran Heritage Museum is a 'must' as there is no better way to get a stimulating overview
of the island's story. Meet 5,000-year-old Clachaig man and investigate a Bronze Age grave.

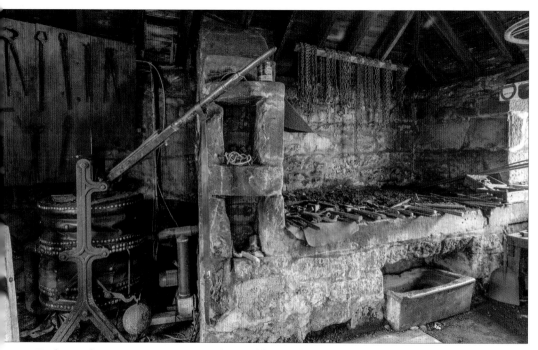

Exploring the Heritage Centre more thoroughly: inside the 'smiddy' (the building on the right, **15** pposite), a fascinating variety of tools and equipment give an insight into the skills this craft requires.

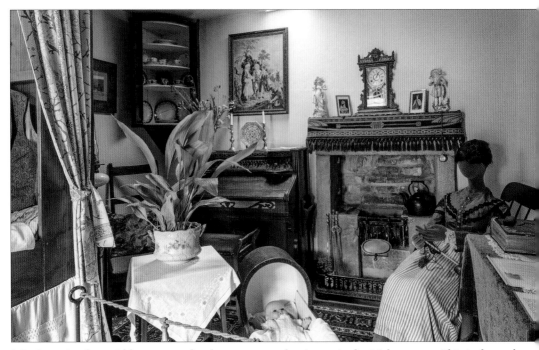

16 Opposite the smiddy, a cottage has been re-created as it was in the 19th century. This is the parlour, full of period artefacts and treasured ornaments.

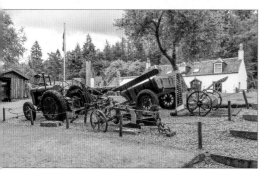

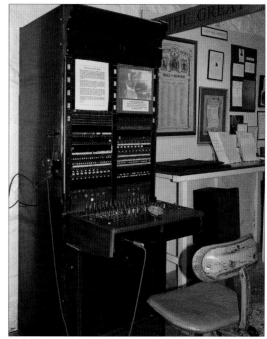

Top left: a bedroom in the cottage; lower left: an array of farm implements of yesteryear; 17
right: the island's original telephone exchange.

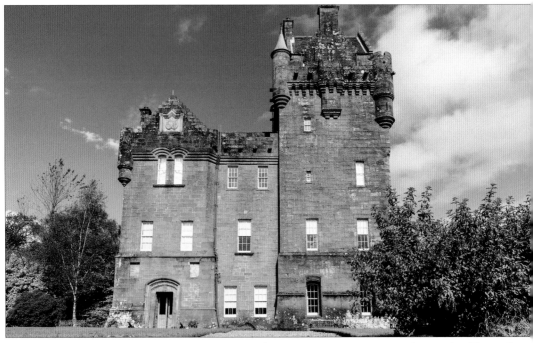

18 With its oldest part dating back to the 13th century, Brodick Castle is a good example of how what began as a fortress has evolved into a country house as conditions and circumstances have allowed.

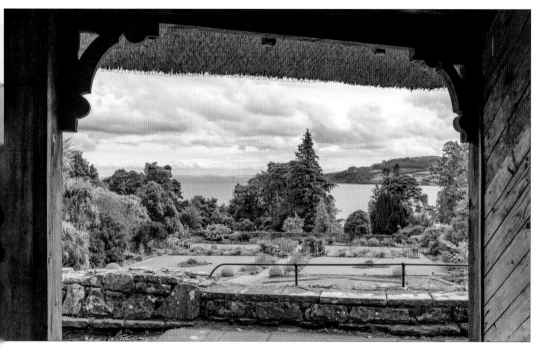

Part of the formal gardens at Brodick Castle, giving an idea of the view over Brodick Bay. The Castle, **19**
Garden and Country Park offer a wonderful combination of heritage, nature, walks and relaxation.

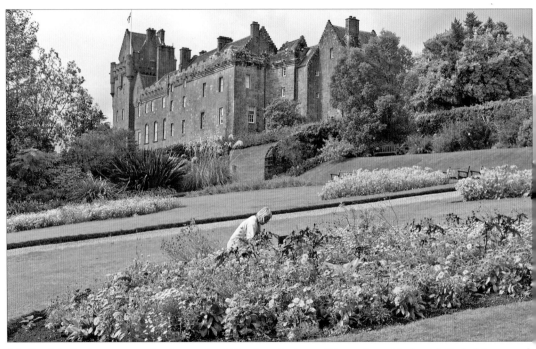

20 Brodick Castle was granted to James, Lord Hamilton, by James IV, together with the title Earl of Arran, and remained in Hamilton hands until 1958 when it was taken into the care of the National Trust for Scotland.

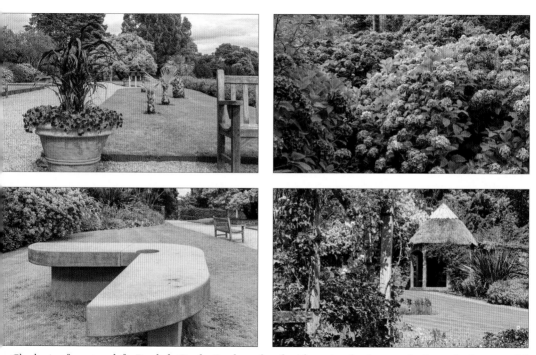

Clockwise from top left: Brodick Castle Gardens detail with a trio of palms on the lawn; hydrangea **21** heaven!; charming garden scene; seat celebrating the 90th birthday of Lady Jean Fforde in 2010.

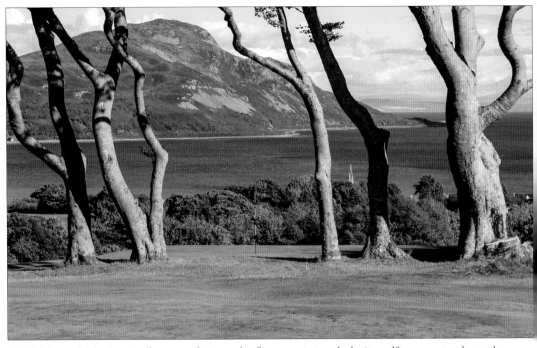

22 Taking a clockwise circular tour of Arran, the first stop is Lamlash. Its golf course stands on the hillside above the village, where these trees frame Holy Island.

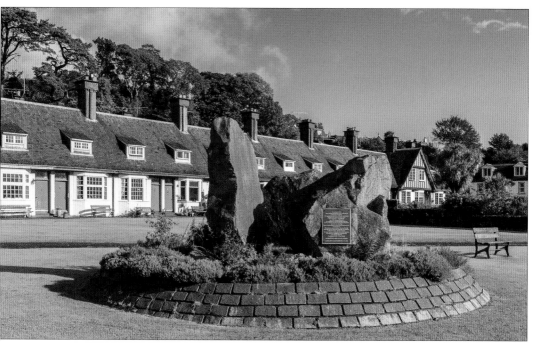

Pictured here in the centre of Lamlash is a poignant memorial to the hundreds who were removed **23** from Arran during the clearance years of 1829-1840.

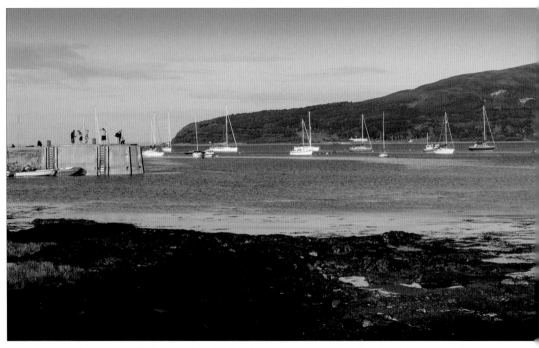

24 The waterfront in Lamlash provides this lovely evening view of Holy Island, so named because of its association with St Molaise (566-640) who lived there as a hermit for a number of years.

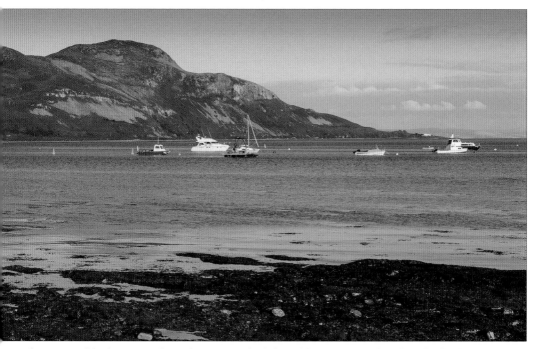

t can be accessed by boat trips from the pier on the left and has some good walks, chiefly the 314m/1030ft summit of Mullach Mor. The island is now a Buddhist retreat.

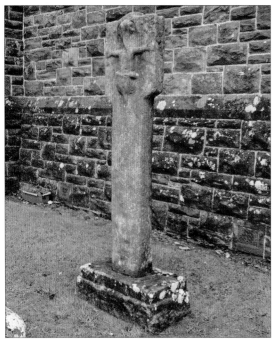

26 Left: an ancient cross outside Lamlash Parish Church, representing St Molaise.
Right: re-cycle a boat with flowers (nice touch!) – a feature of Lamlash and Whiting Bay.

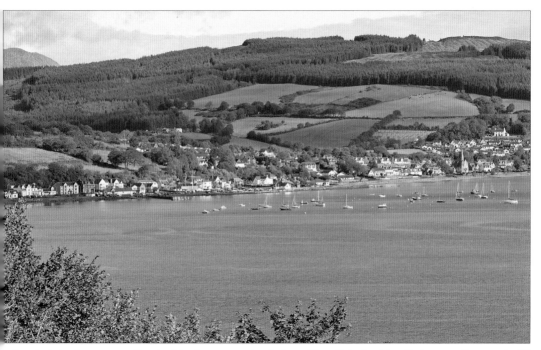

Lamlash looks so appealing in this view across its sheltered bay. It is the island's largest village and **27** architecturally most attractive settlement thanks to an array of elegant Victorian buildings.

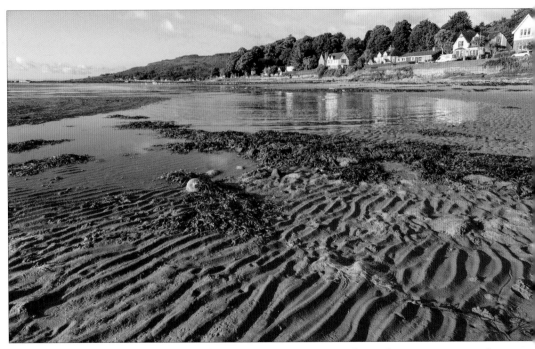

28 Whiting Bay is the next settlement down Arran's eastern coast. This early-morning view with low-lying light was a great moment to capture.

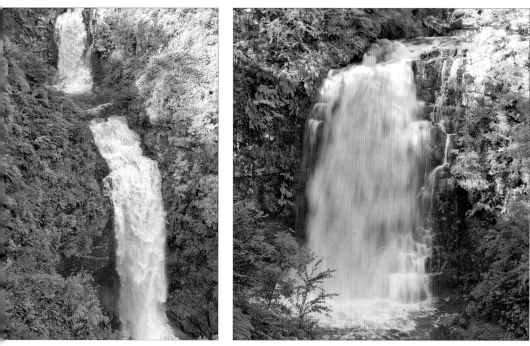

Follow the path at the south end of the village to the impressive Glenashdale Falls. Left, both main **29** cascades are captured sharp while on the right the upper falls are seen with long-exposure blur.

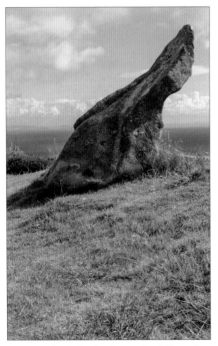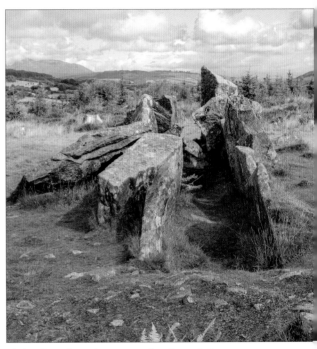

30 On the hillside above the falls is the Neolithic burial site known as the Giants' Graves.
Left: one of the perimeter stones. Right: the remains of the chambered burial cairn.

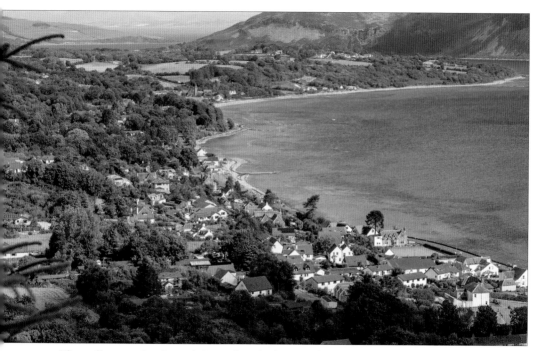

The walk up to the Giants' Graves has the bonus of providing spectacular views down to **31** Whiting Bay. The back cover picture was also taken on this route.

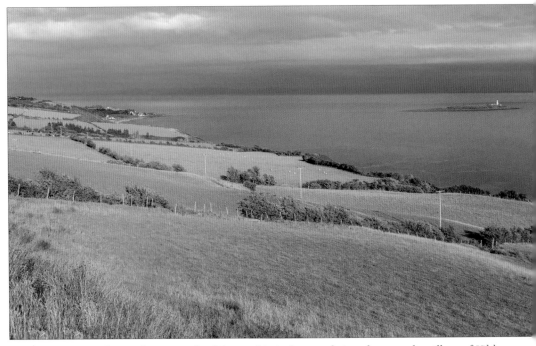

32 Moving on to the southern stretch of Arran, this is the grand view down to the village of Kildonan, showing the island's more pastoral side. The island of Pladda (with lighthouse) sits away to the righ

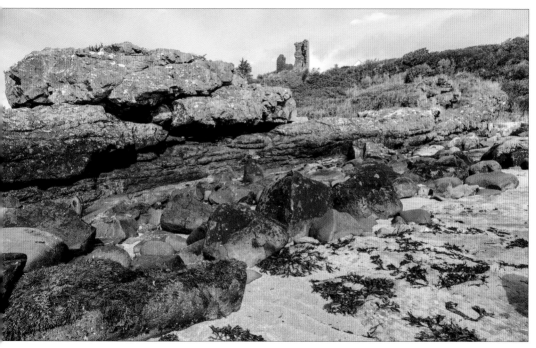

Much of Arran's coast is rocky, with features like this craggy outcrop which crosses Kildonan's beach **33** on its way to the sea. The ivy-clad remains of Kildonan Castle look down on this geology.

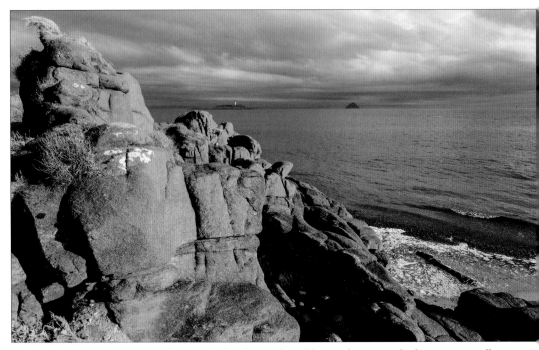

34 Strong evening sun warms these eroded rocks on the Kildonan shore. On the horizon, as well as Pladda, the impressive 338m/1109ft volcanic plug cone of Ailsa Craig draws the eye further out to sea.

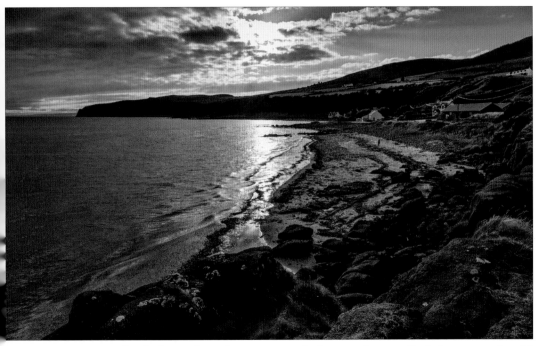

Turning around to look west from the same spot, the low sun throws a final gleam on to the **35** wavelets that lap the beach. Arran at its tranquil and relaxing best!

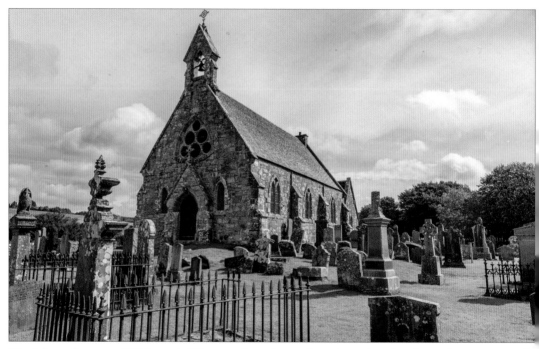

36 A few miles west of Kildonan is Kilmory, where the small yet imposing church stands in a graveyard full of interest. It was built in 1880 over the previous building of 1765.

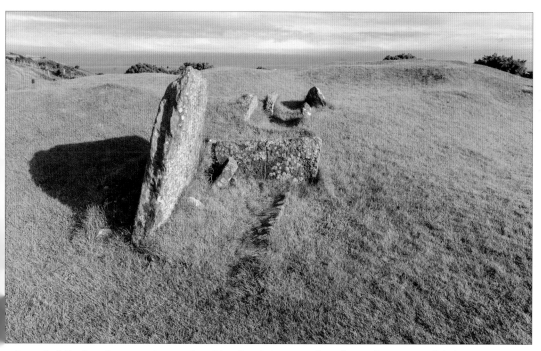

Arran is full of ancient remains, such as Torrylin Cairn near the village of Lagg. People's bones were buried here over 5,000 years ago. Even now, the cairn's remains are around 20m/65ft long.

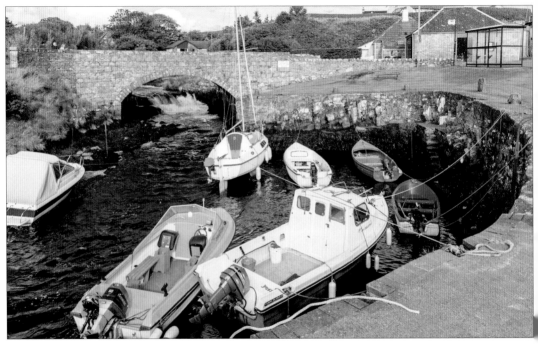

38 Beyond Lagg, the coast curves northwards, leading to the village of Blackwaterfoot on the now west-facing coast. This is its 'bijou' harbour, with waterfall in full flow neatly framed in the arch of the bridge

The charming harbour scene is nicely contrasted by the invigorating image of Blackwaterfoot's beach, a great place for a brisk walk to very interesting things beyond . . .

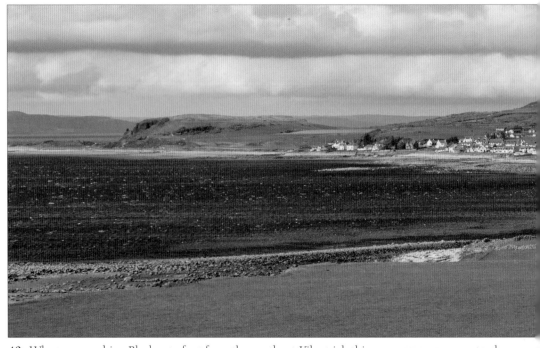

40 When approaching Blackwaterfoot from the south, at Kilpatrick this panorama opens up to show
the village's location in its wider setting. The west coast is by far the less developed side of Arran,

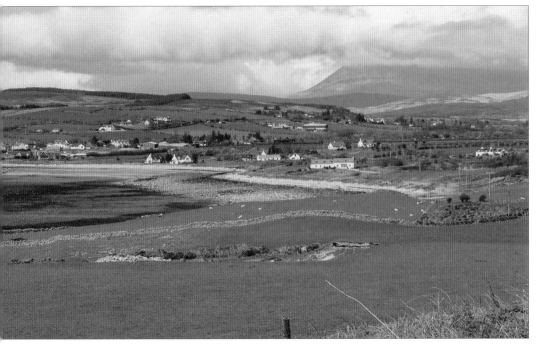

with Blackwaterfoot the only sizeable (by Arran standards!) settlement on this side of the island.	**41**

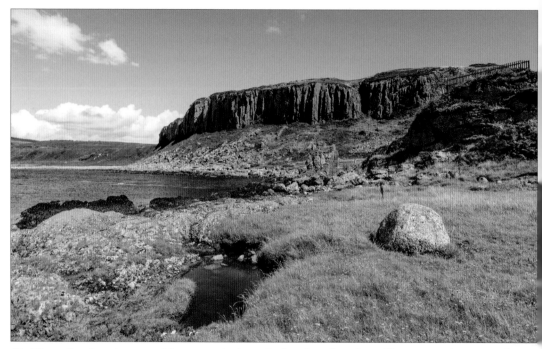

42 The walk referred to on p.39 goes north along the beach and via the golf course to The Doon, the impressive columnar basalt feature pictured here. A path skirts its base and then leads up around the

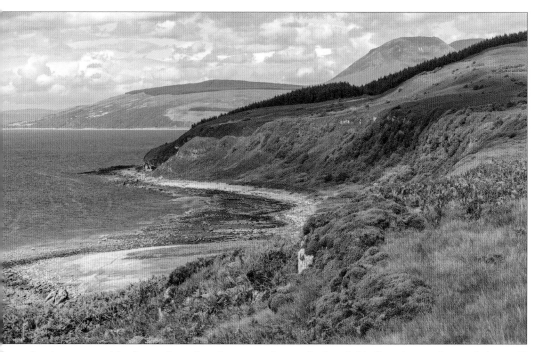

far end to its eastern side, from where the plateau can be reached and this fine view to the north is
revealed. The Doon used to be the site of a hill fort, slight remains of which can still be made out.

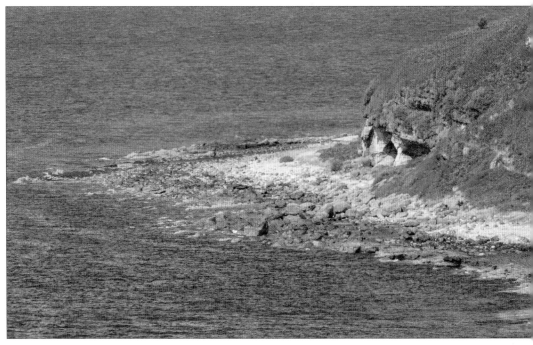

44 A little further up the coast is the King's Cave, the entrance to which is seen here. As well as its
association with King Robert the Bruce, the cave contains Christian and pre-Christian carvings.

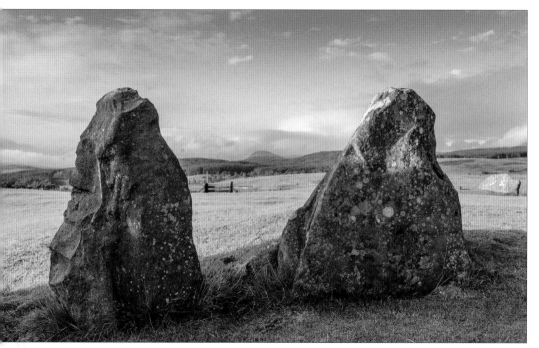

Machrie Moor is the epicentre of ancient activity, where a network of 11 sites speaks of huge effort
over many centuries. These two stones are part of Moss Farm Road cairn/circle and are passed

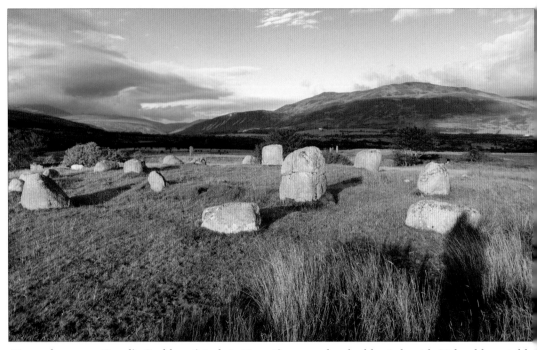

46 on the way to Fingal's Cauldron (Machrie Moor 5), a complex double circle with 25 boulders visible but evidence of more in former times. The single stone in the distance is that shown on p.6.

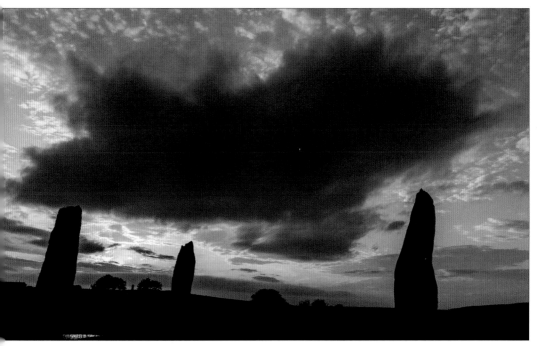

ust visible further to the right are the three pictured above, against the backdrop of a stormy sunset. **47**
This group is known as Machrie Moor 2 and is thought to date to about 2000BC.

48 Naturally, seabirds are abundant on Arran. Left: there's always one! Everyone else has spotted something he seems to have missed. Right: a Black guillemot with undercarriage ready to splashdown

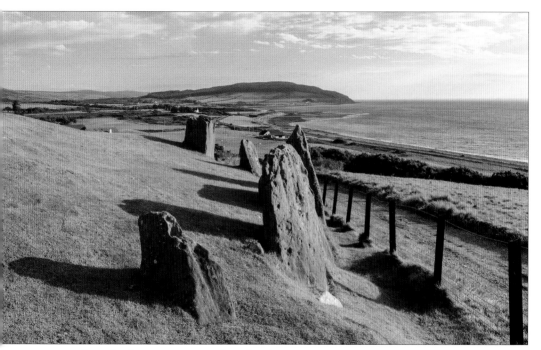

Continuing northwards, these stones at Auchagallon form a circle; but it is not clear whether they are **49** a stone circle as such, or the kerb stones of a cairn. A cist (stone coffin) was found here in the 1800s.

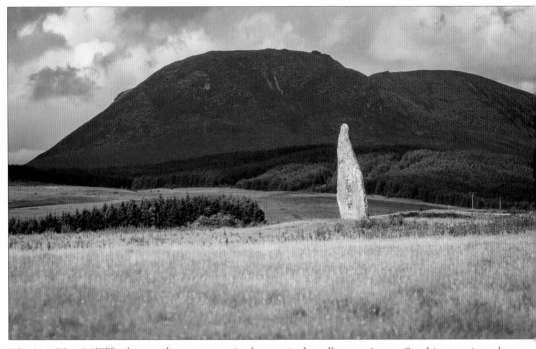

50 At 4.79m/15'7"ft, the standing stone at Auchencar is the tallest on Arran. On this occasion, the stark contrast between the sunlit stone and deeply shadowed bulk of Beinn Bharrain is dramatic.

From Kintyre looking across Kilbrannan Sound, the village of Pirnmill can just be made out below **51** hills to the north of Beinn Bharrain (the two summits on the right), collectively the Pirnmill Hills.

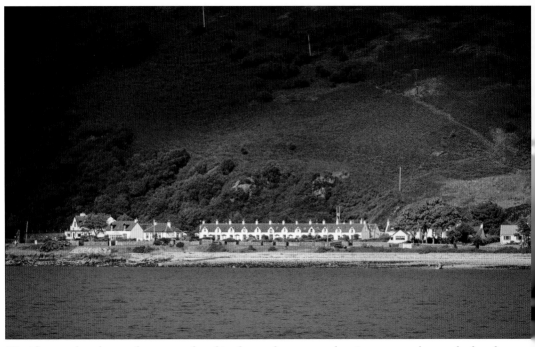

52 After another three miles or so, a bend in the road opens up the vista across a bay to the hamlet of Catacol, in which the impressive terrace of 12 cottages known as the 12 Apostles dominates the

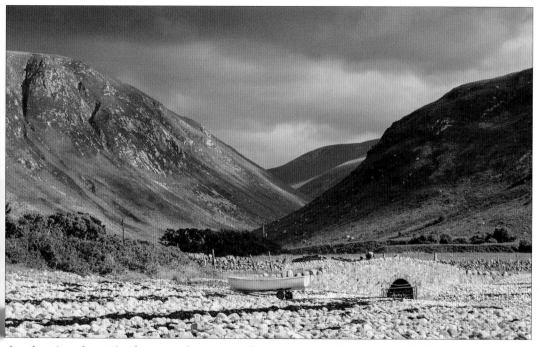

shoreline (see also p.1). Above, another contrast between sun-soaked slopes and a threatening sky shows Glen Catacol winding enticingly into the distance.

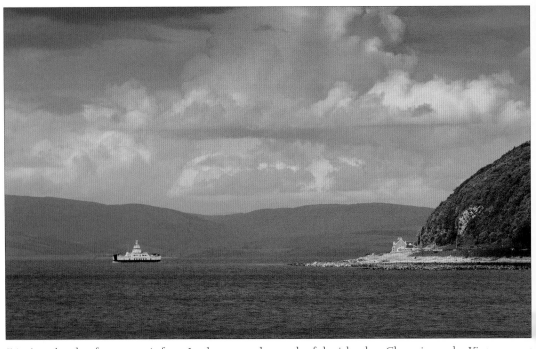

54 Arran's other ferry route is from Lochranza at the north of the island to Claonaig on the Kintyre peninsula. Here, the ferry has just departed Lochranza, looking so small against the big landscape.

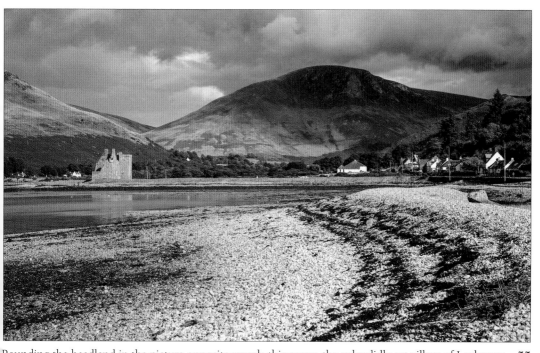

Rounding the headland in the picture opposite reveals this scene: the splendidly set village of Lochranza, **55** complete with its fine castle guarding the bay. The castle replaced an earlier, 13th-century, structure.

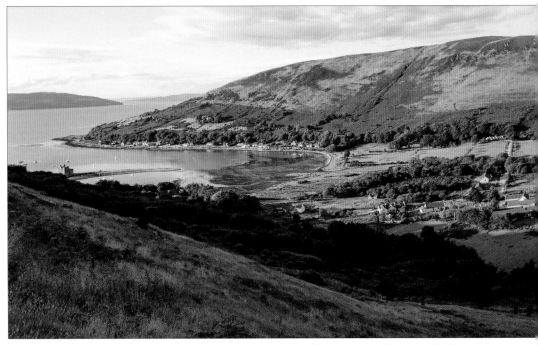

56 Lochranza is Arran's most northerly settlement, spaciously strung out along the final mile of Glen Chalmadale, as this image from its southern slopes shows. The 16th-century castle's strategic

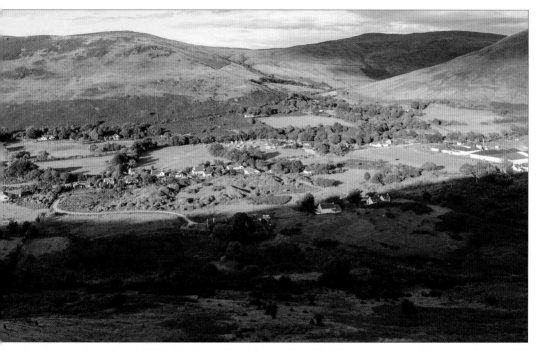

…ocation is seen from above (left) right through to the modern distillery at extreme right – in effect a 57 time-line of the village's history. A panorama that captures the essence of Arran.

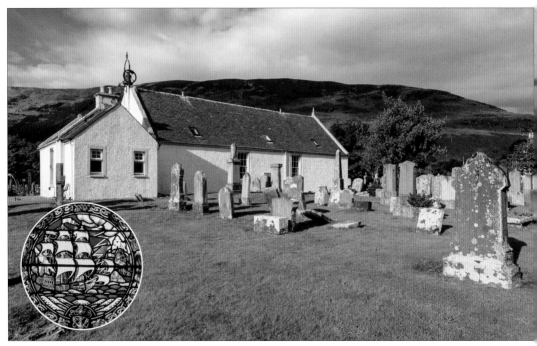

58 St Bride's: there has been a church on this site in Lochranza since medieval times. Inset: this stained-glass window depicts the ship of the Gospel, sailing through the troubled seas of life.

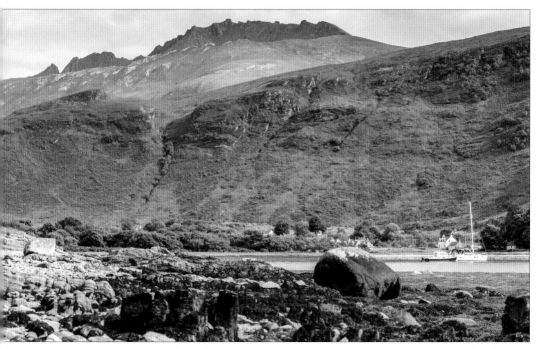

From the north side of Lochranza bay, this truly spectacular mountainscape stands tall, arguably the **59** most impressive (or scary, depending on your point of view!) mountain 'architecture' on the island.

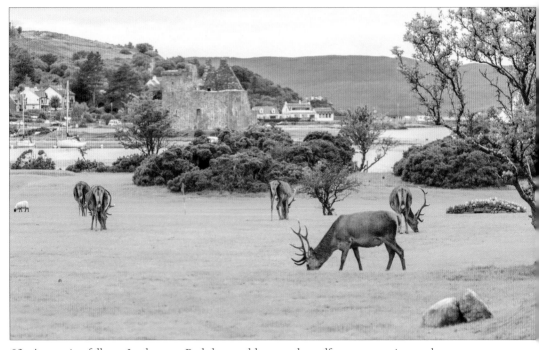

60 As evening falls on Lochranza, Red deer amble onto the golf course, grazing as they go. The question is: do they deliberately wait until the golfers have gone for the day?

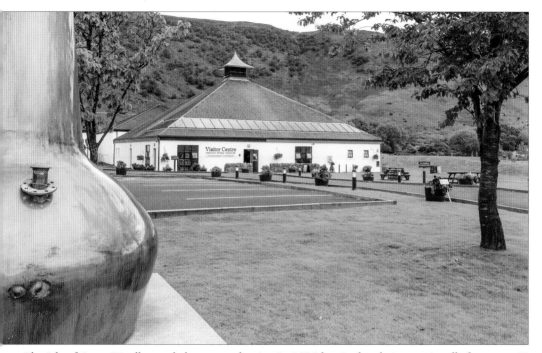

The Isle of Arran Distillery only began production in 1995 but is already internationally famous. **61**
This is its Visitor Centre. At the time of writing, a sister distillery is being built in the south of Arran.

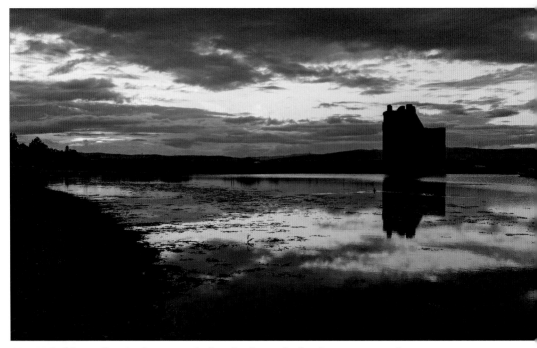

62 We bid farewell to Lochranza with this absolute gift of a glorious, tranquil sunset.

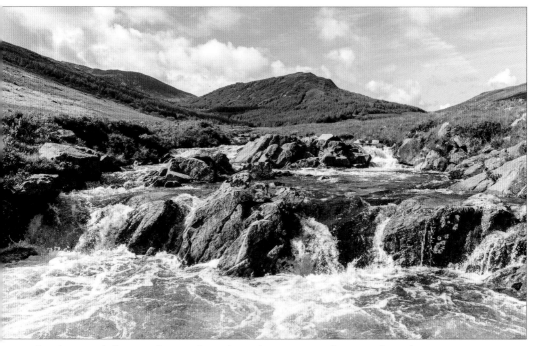

Now heading south from Lochranza through north-east Arran, the route skirts the mountains seen **63** on p.59. This is North Glen Sannox burn, near the beginning of the path to those craggy peaks.

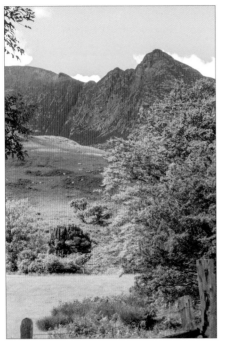 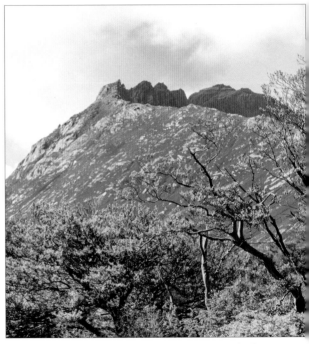

64 The Arran mountains provide plenty of scrambling opportunities. Left: Cioch na h-Oighe has a difficult ascent. Right: an end-on view of the ridge seen on p.59.

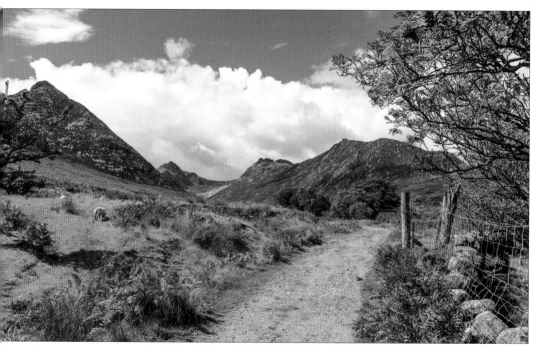

The other path into Glen Sannox starts from Sannox itself. The view soon opens up to reveal the
climbing choices: Cioch na h-Oighe on the left, Cir Mhor in the distance and Caisteal Abhail, centre.

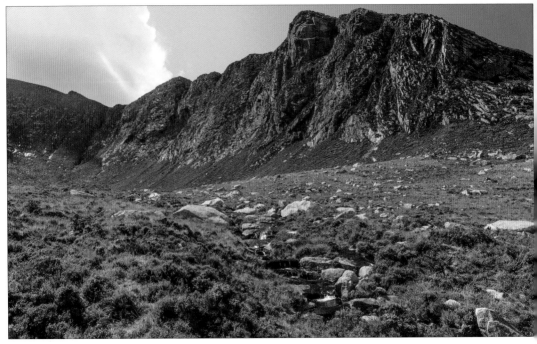

66 The route to Cioch na h-Oighe can take in the somewhat fancifully named Devil's Punchbowl. It's a good walk in its own right, blending dramatic cliffs with a refreshing mountain stream.

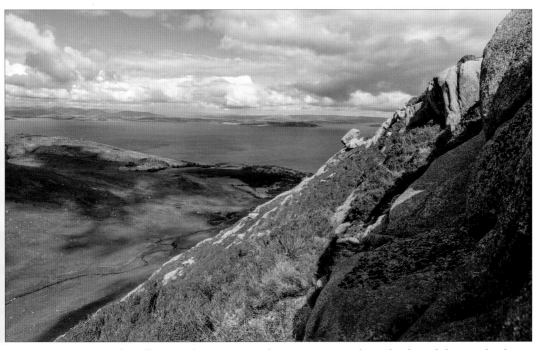

It also offers grand vistas across the sea to surrounding islands and the mainland. **67**
This view, from the northern slopes of Cioch na h-Oighe, looks across to the Isle of Bute.

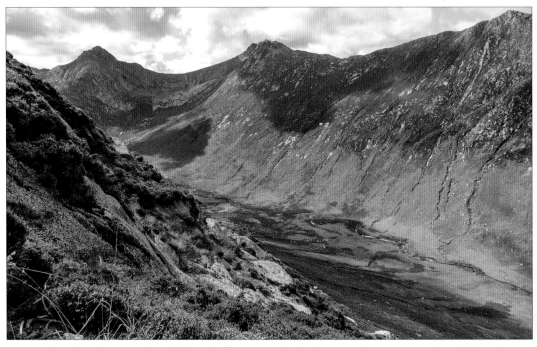

68 Looking the other way (south) from the same spot leads the eye to the upper reaches of Glen Sannox, with, from left to right, Cir Mhor, Caisteal Abhail and Suidhe Fhearghas on the skyline.

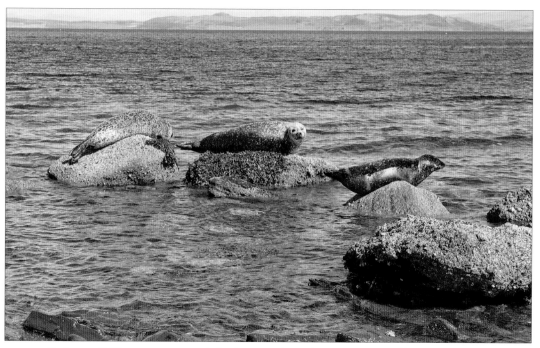

Seal appeal! These common seals basking on the rocks near Sannox village are so endearing. **69**
Although seal numbers around Scotland in general are falling, there seem to be plenty in Arran.

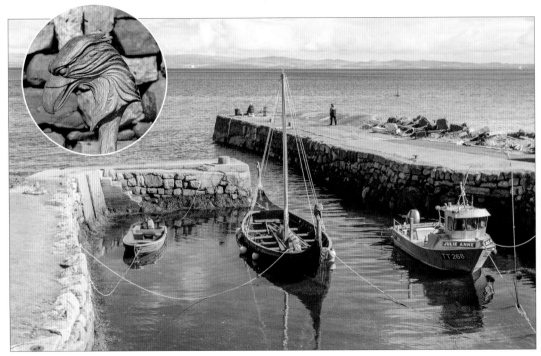

70 Charming Corrie has not one, but two, harbours. At the northerly one, Corrie Port, a replica Viking Longboat is a surprising sight. Inset: figurehead on the longboat.

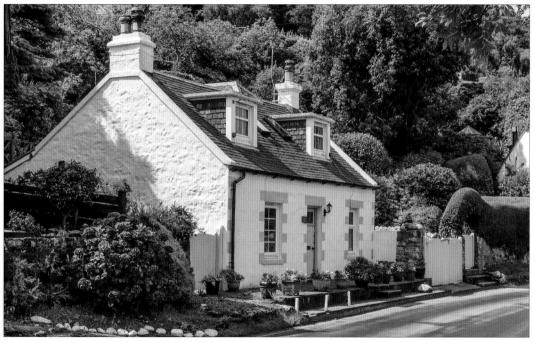

A further aspect of Corrie's charm is the variety of cosy-looking and beautifully maintained cottages.

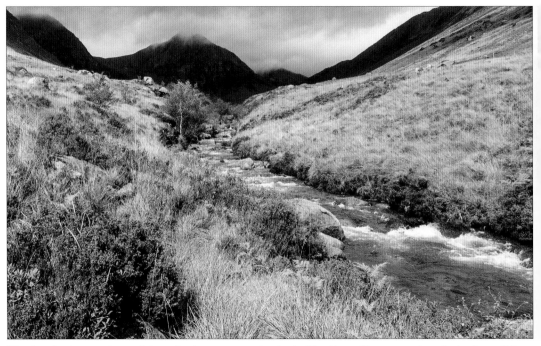

72 Another impressive path into the Arran mountains is via Glen Rosa. Here, on a day of mixed conditions, there is sun on Glenrosa Water and the heather, while Cir Mhor (centre) lurks in the clouds.

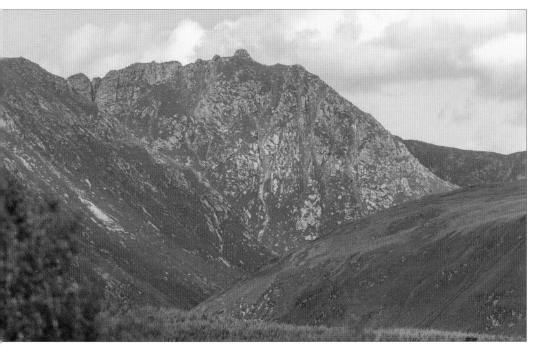

One of the peaks to the west of Glen Rosa is A Chir (745m/2444ft). In this long-distance view, **73** the line of Glen Rosa can be detected at the bottom of the picture.

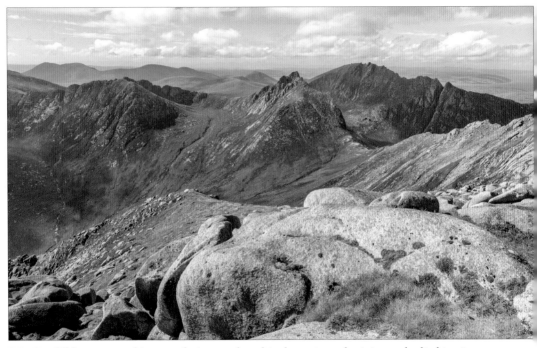

74 Goatfell has appeared in several pictures, but this shows just why it is worth climbing it. Here, looking north-west from the summit, are Cir Mhor (centre) and Caisteal Abhail to its right.

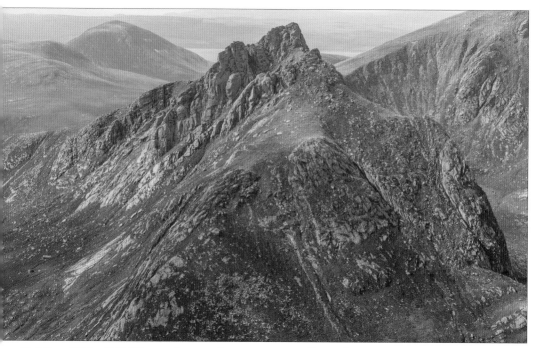

Cir Mhor (798m/2618ft), seen here in close-up, is generally rated as Arran's most dramatic peak. **75**
It sits right between the two main ridges of the Arran mountains, which adds to its prominence.

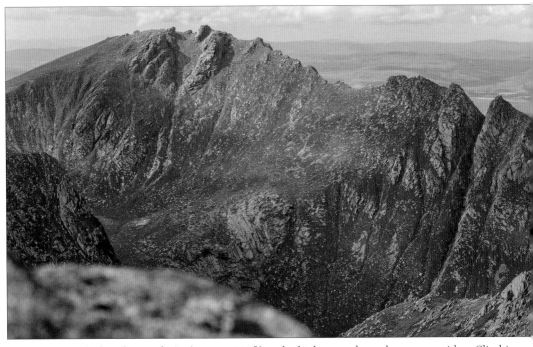

76 Caisteal Abhail - 'The Castles' - (859m/2818ft) is the highest peak on the western ridge. Climbing it via the Witches' Step (right, and p.7) adds an exciting obstacle to the trek, but it can be bypassed

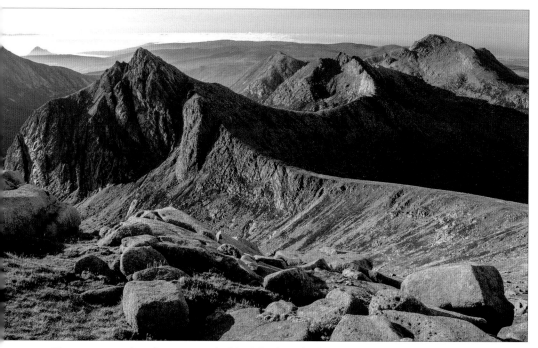

This image is taken from Caisteal Abhail, looking back along the joining ridge to Cir Mhor, from where another ridge stretches towards A Chir. The peak at top right is Beinn Tarsuinn.

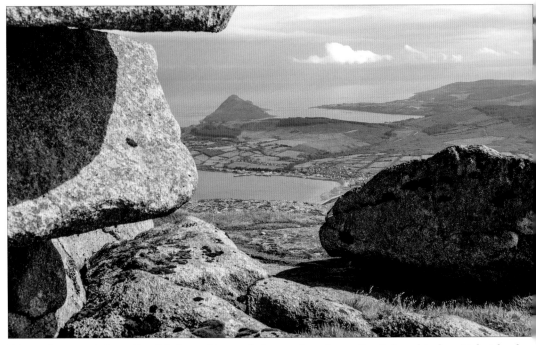

78 Looking south from Goatfell, framed by eroded summit rocks are Brodick and its bay, Holy Island (the peak that appears to meet the mainland), Lamlash Bay, Kingscross Point and Whiting Bay.

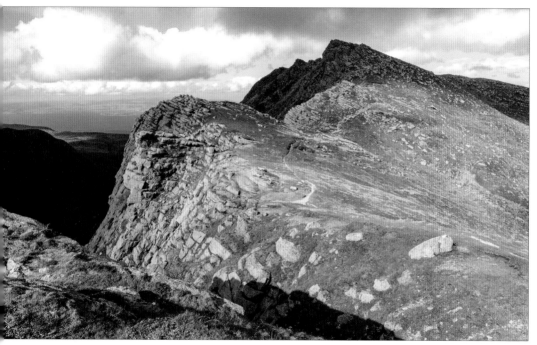

And finally, the northerly aspect shows the steepness of the drop into Glen Sannox and the path leading to Mullach Buidhe (829m/2719ft), its summit in shadow. Amazing Arran!

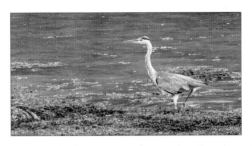

Published 2019 by Lyrical Scotland, an imprint of Lomond Books Ltd, Broxburn, EH52 5NF
www.lyricalscotland.com www.lomondbooks.com

Originated by Ness Publishing, 47 Academy Street, Elgin, Moray, IV30 1LR

Printed in China

All photographs © Colin & Eithne Nutt except p.10 © Guthrie Aerial Photography;
p.12 © Carolyn Mcdonald and p.77 © Keith Fergus;

Text © Colin Nutt
ISBN 978-1-78818-074-0

Front cover: Brodick Bay and Goatfell; p.1: garden of one of the '12 Apostles', Catacol; p.4: Red deer hind;
this page: heron at Lochranza; back cover: Whiting Bay from Giants' Graves